* * T R O L L E Y * *

ECHOES

Photographs
Chris Steele-Perkins

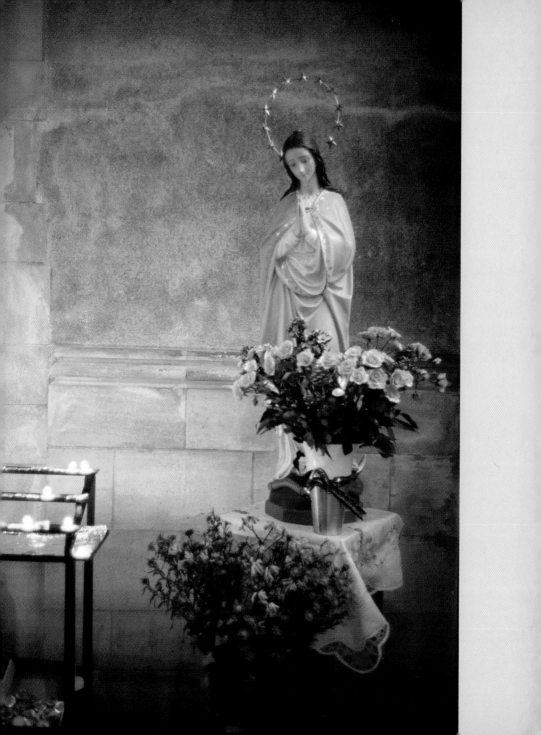

I am a part of all that I have met;
Yet all experience is an arch wherethro'
Gleams that untravell'd world, whose margin fades
For ever and for ever when I move.

Alfred Lord Tennyson, *Ulysses*

For Miyako, Michael, Cedric and Cameron

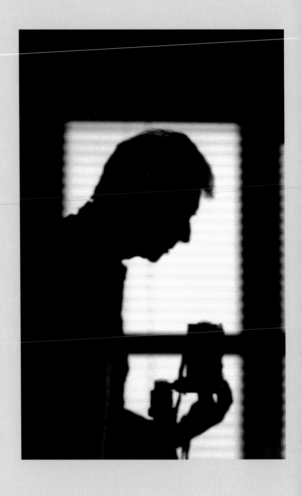

Self portrait at home

New Year's Eve of 2001 was crisp and bright.

Walking through the Surrey countryside
with my wife, my two sons and a couple
of friends, David and Annie. The landscape
belong to us as we crunched over frosted
leaves and mud, misting breath into
the cold air, crossing small stone and
wooden bridges where streams carried away
the twigs the boys dropped in; past brambles
and an abandoned factory. Voices
disappearing into the woods and across
the empty fields. A low winter sun.
I took some photographs as I always do
on such outings. Photos of us, the landscape,
plants and buildings. We climbed up to a
church on the Pilgrims' Way as the light
began to fall away, and reached our cars
as the dark closed in. Back to a warm house,
food by candle light, drink, TV, children
washed and sleeping, my wife's embrace
in a comfortable bed. The last remarkable,
unremarkable day before the New
Millennium.

I thought about the photos I take; the
mementoes I bring back from distant parts
of the world and odd corners of the nearby;
the life I lead wandering around with
my cameras, sucking images from the flux
around me, both as my work and as my
compulsion; collecting these traces of time
with my little black box. How, with every
choice I make of omission and selection,
the way every picture is made; how every
photograph I take holds a part of me.

The year reeled out at breakneck speed.
The events that define our History flared
and fused. The children grew. The garden
changed. I travelled, worked, loved, grieved,
moving here and there, across the disrupted
rhythms of nature, across the continents,
finger on the shutter-pulse of mine.
This was the year my mother died; body
consumed by flames; ashes cast amongst
the ivy and the grass of a small church
in Northampton.

Days shortened. Winter gathered in. Another
year was taken. The fragments from that
time were gathered up and are laid out here:
a broken reconstruction, a silent echo
of the year I left behind.

The New Year's morning of 2002 was lovely,
crisp and bright. I argued and made up with
my wife. Walking through the Kent
countryside with Miyako, my two sons and
a couple of friends, David and Annie;
mistletoe in the oaks, sticky clay underfoot,
oldman's beard catching the low winter light,
we raised our hands in greeting to our long
shadows, to the past year, to the new.

I took some photos.

My wife Miyako and my son, Cedric play pick sticks on New Year's Eve 2000

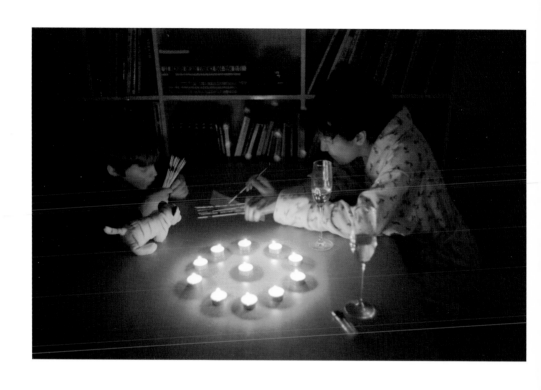

Looking up from my garden in London at an early morning mackerel sky

Family and friends on a walk in Surrey on New Year's Eve 2000

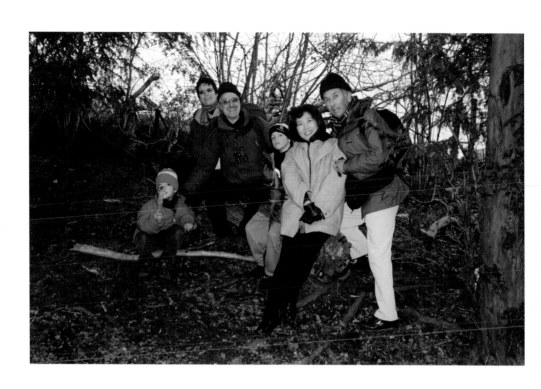

Miyako's hair in sunlight through the back window

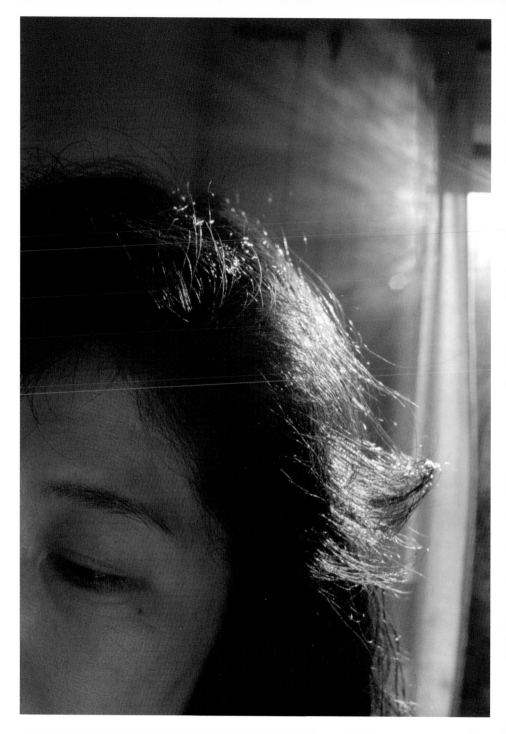

My son Cameron playing with Pokemon cards at home
*Overleaf*: Subway at Heathrow airport after leaving Miyako who was returning to Japan

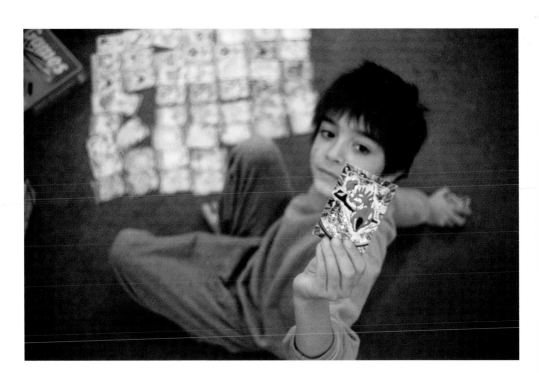

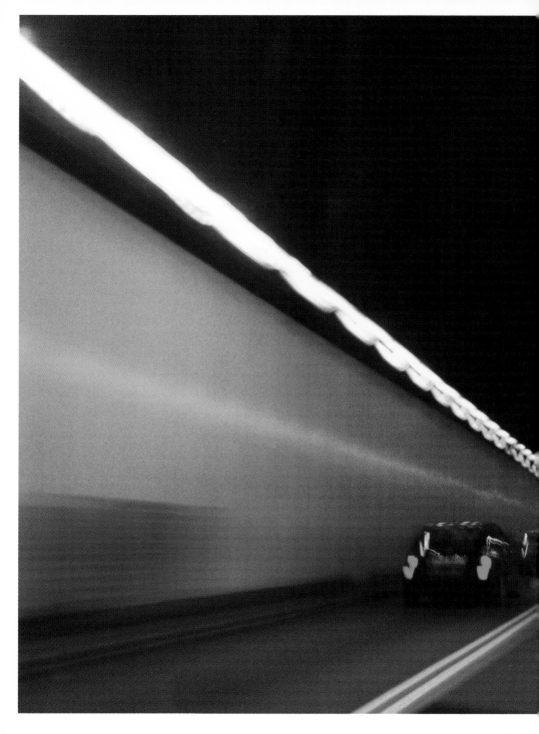

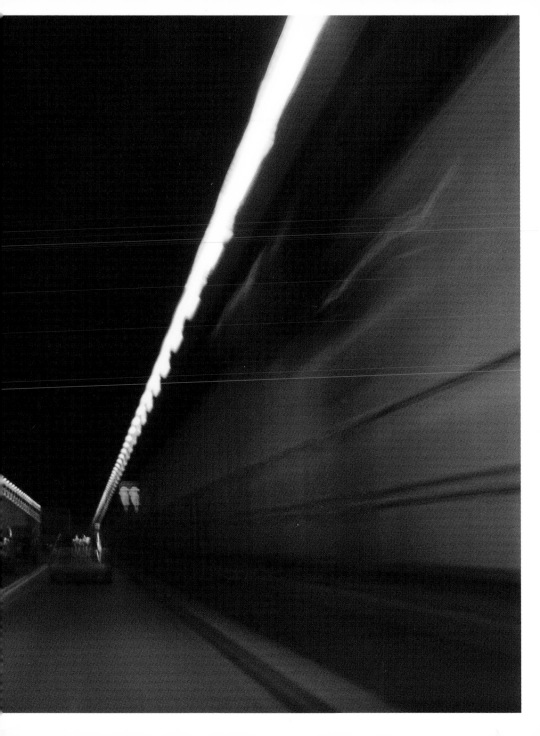

Teddy lying on a bed after the boys have gone back to school

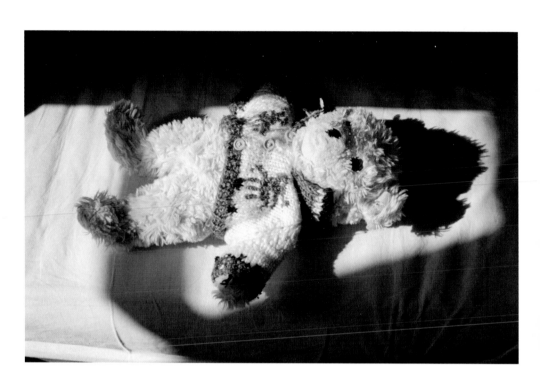

Reflections of Miyako in a hotel window

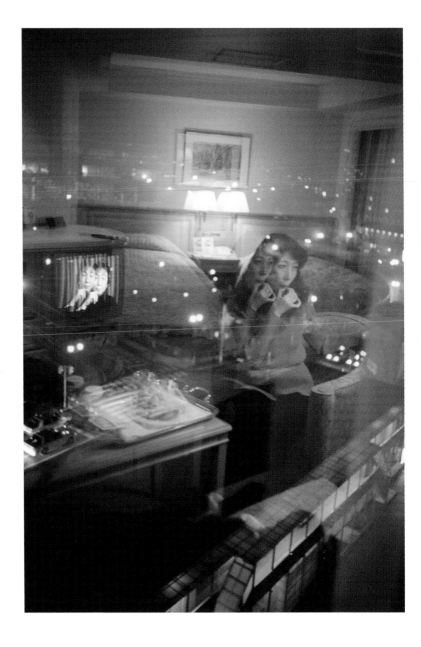

Cabbage field in car headlights after day photographing on my Fuji book
*Overleaf*: Raindrops on a hotel window in Isumo

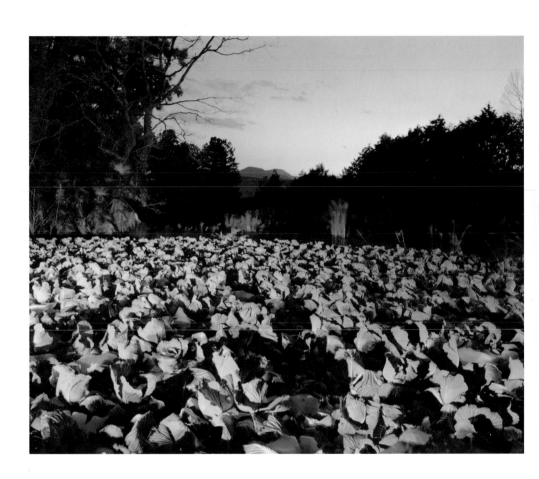

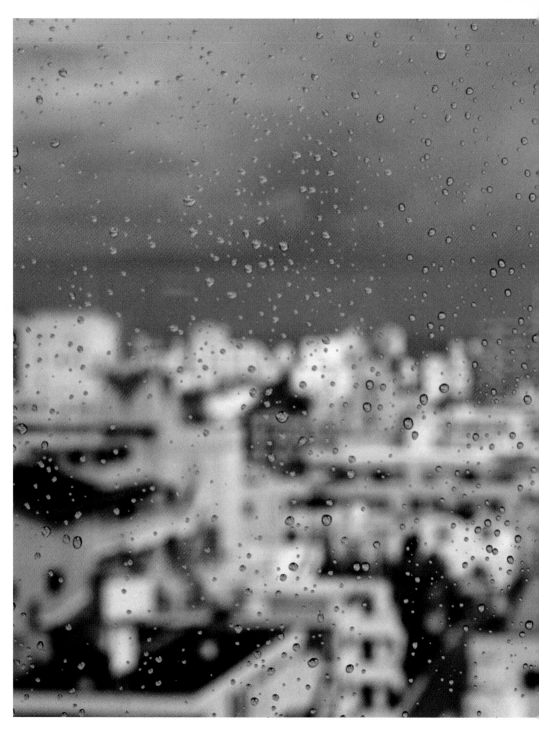

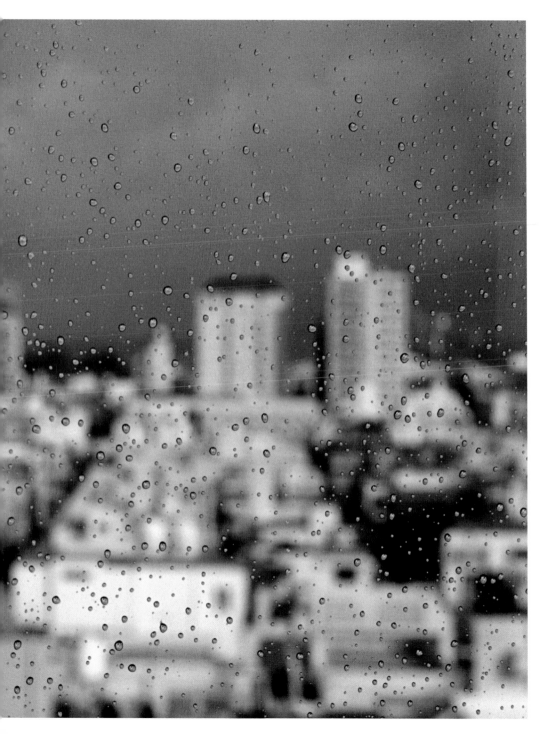

New heavy snow in Tokyo near Miyako's home

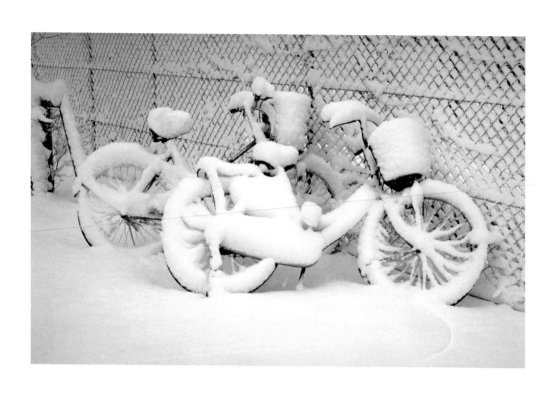

Landscape on the way back to Tokyo from photographing on my Fuji book
*Overleaf*: Materials laid out beside the road near Mt Fuji

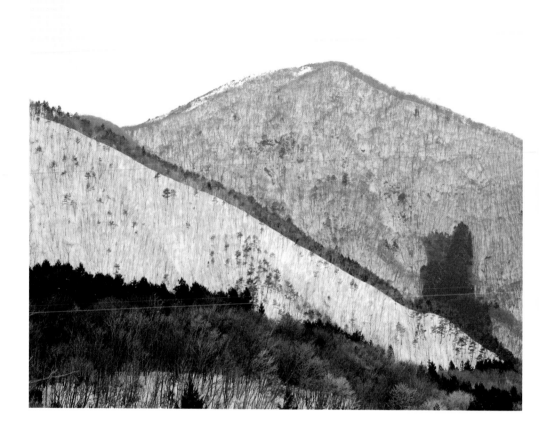

Looking out from a restaurant in Tokyo

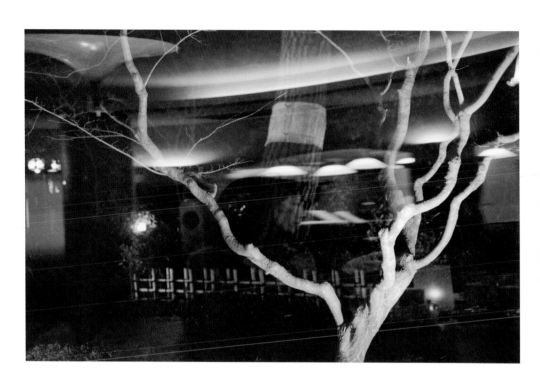

Truck driver in Tokyo
*Overleaf*: Filling station and Mt Fuji near Shiraito Falls

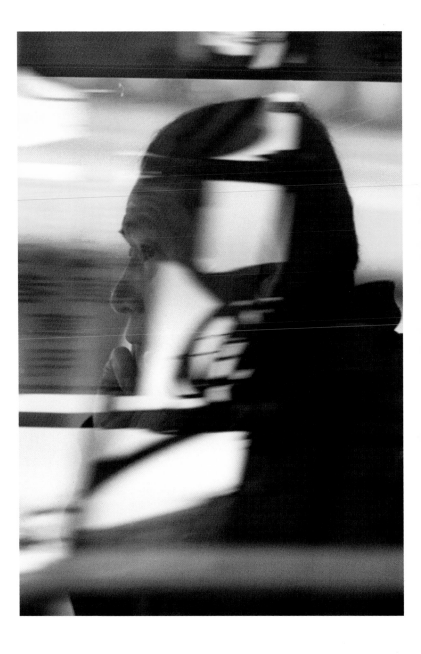

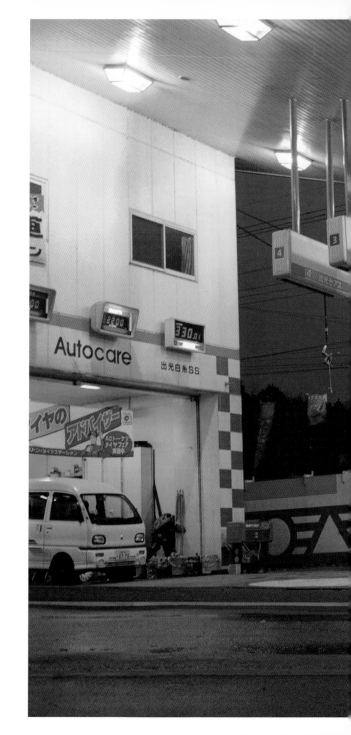

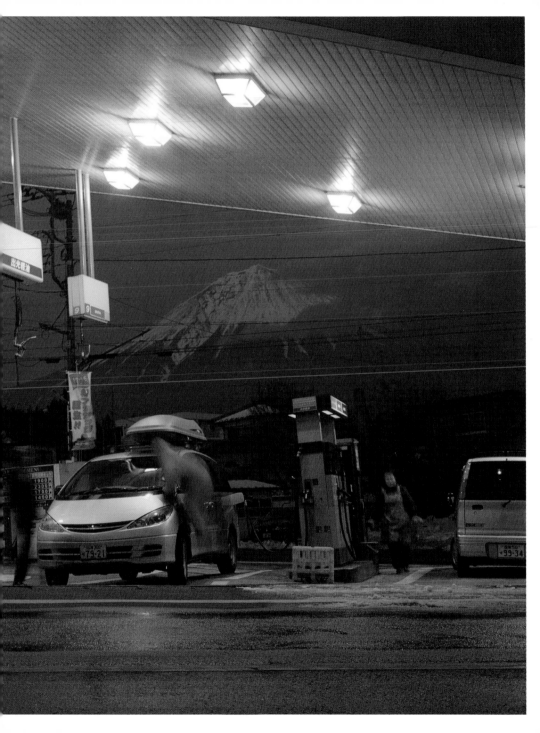

Cut out of faceless monk used to take comic photos in Tokyo

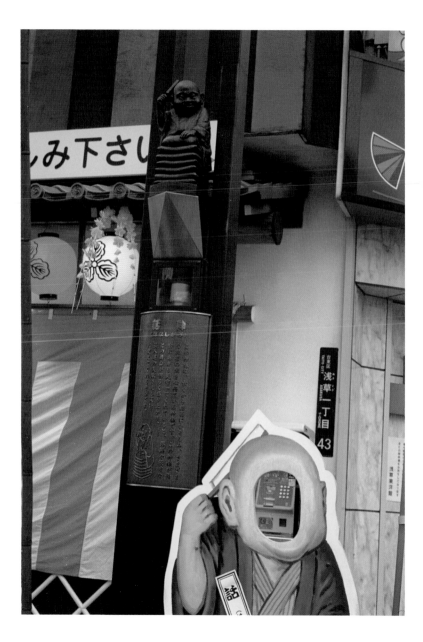

Visiting my sons in Switzerland where they go to school,
we passed over a bridge and this lone dog

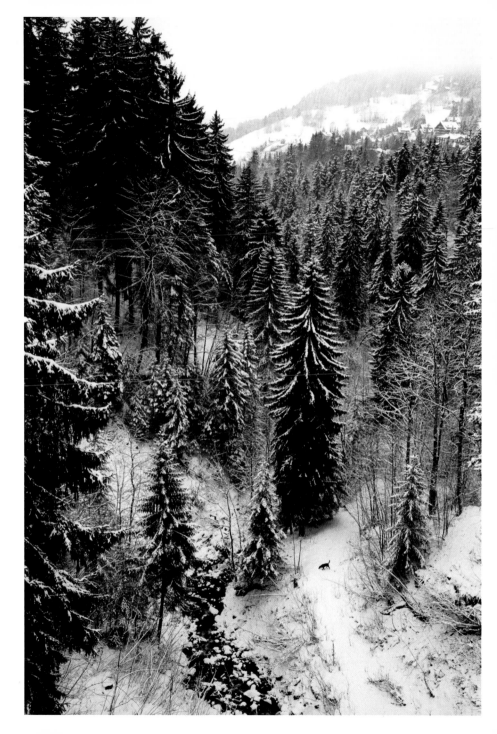

Cherry blossom in the car park of the Fox on the Hill pub in Dulwich

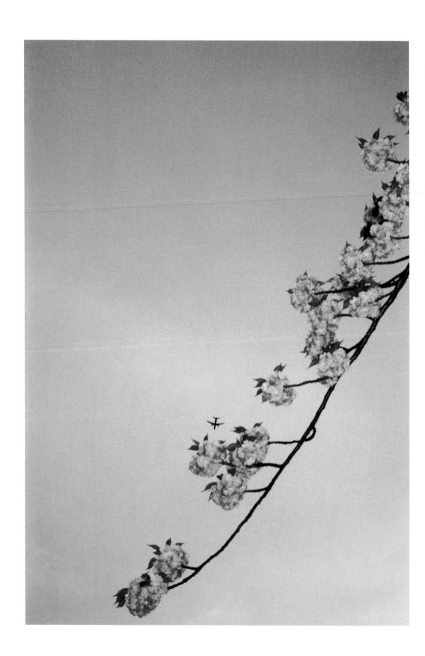

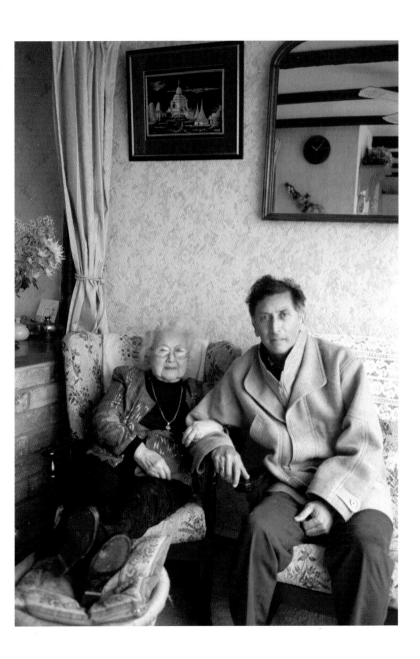

The last picture, taken by Miyako, of me and my mother together
in her home in Northampton

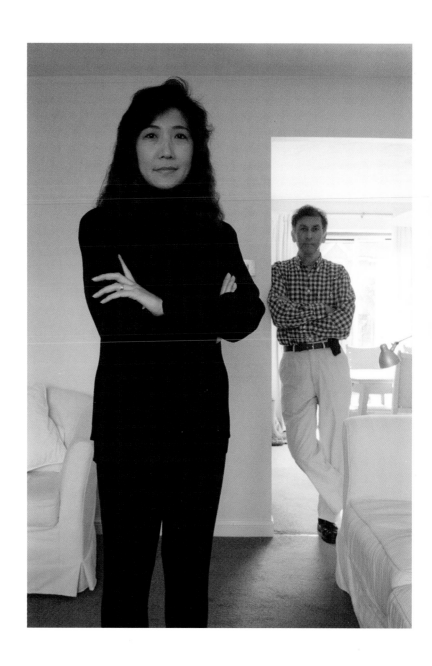

Spring. Miyako and me in the living room

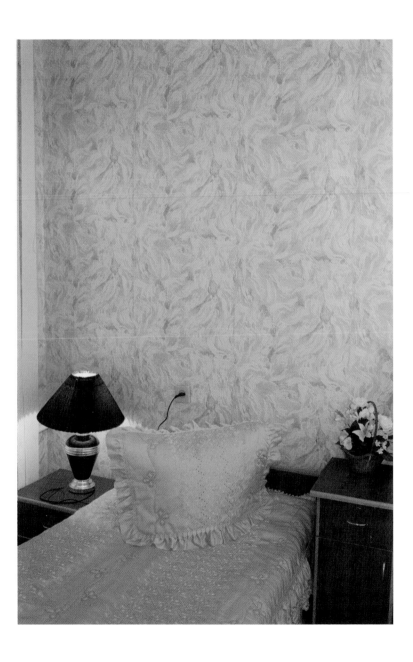

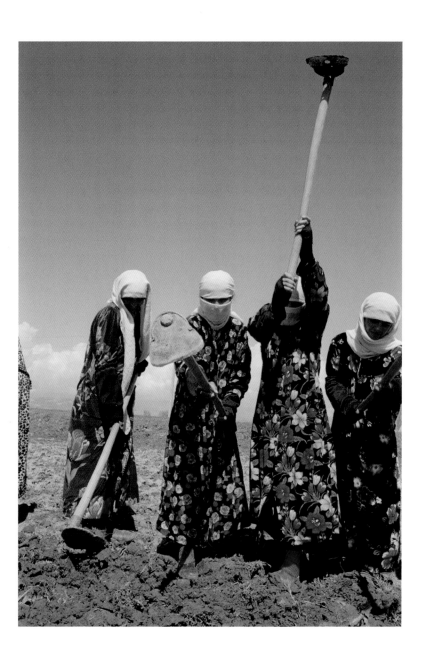

Women working in the fields in Tajikistan
*Right*: Table prepared for a neighbourhood party in Tajikistan

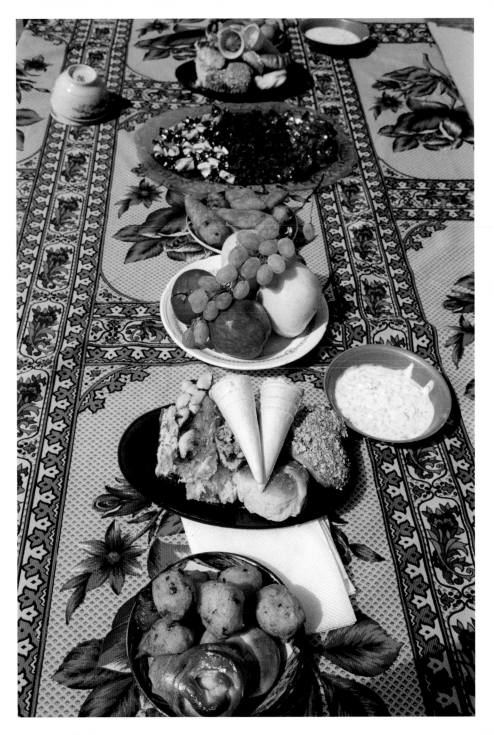

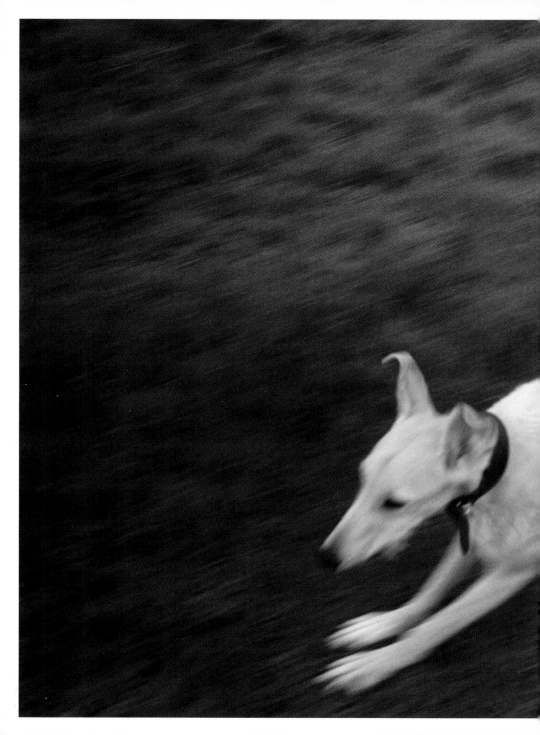

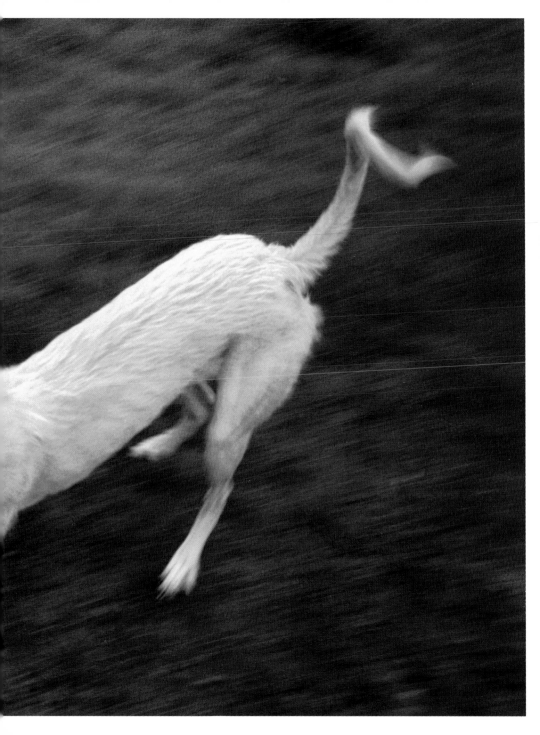

*Previous*: Dingo, a lurcher belonging to friends
Cedric plays Gameboy while Cameron watches TV at home

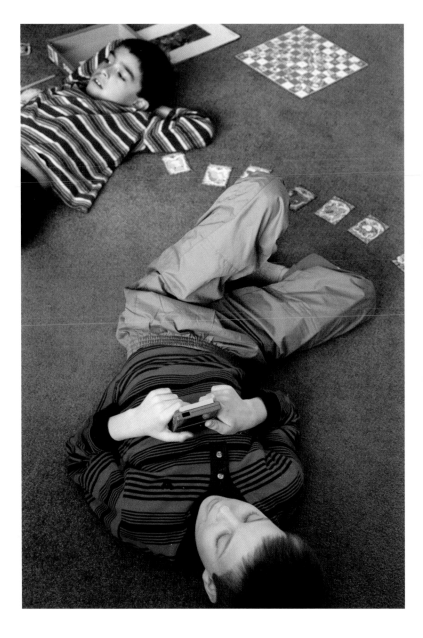

Police line at anti capitalist demonstration in London

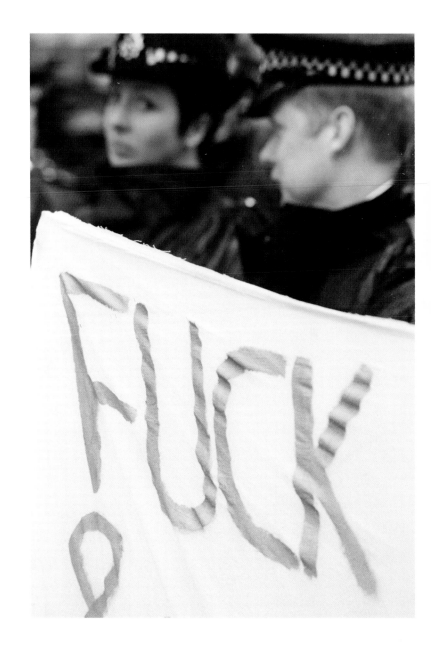

A dew pond passed on a walk with friends on the South Downs

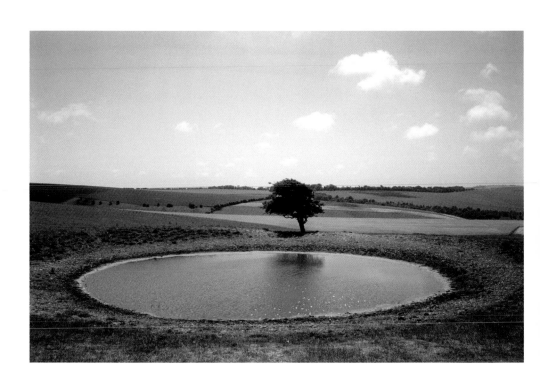

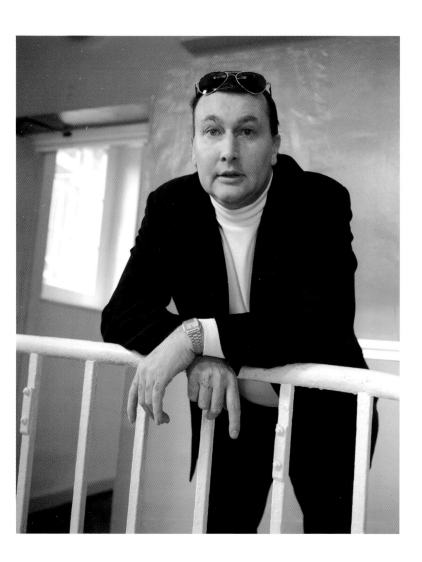

A portrait of a homeless man taken for St. Mungo's, a homeless charity, in one of their hostels in London

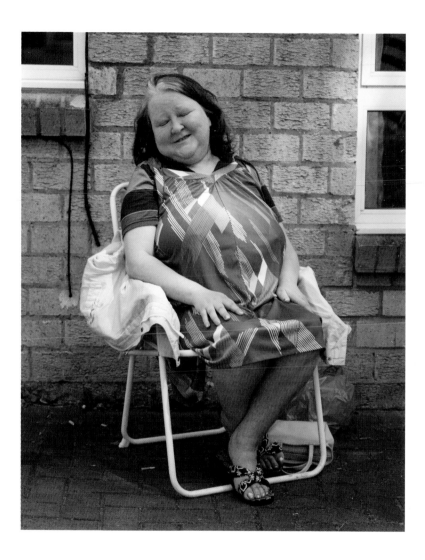

A homeless woman in a St. Mungo's hostel in London

I collected Miyako from the airport and took her to see the rhododendrons in Dulwich Park

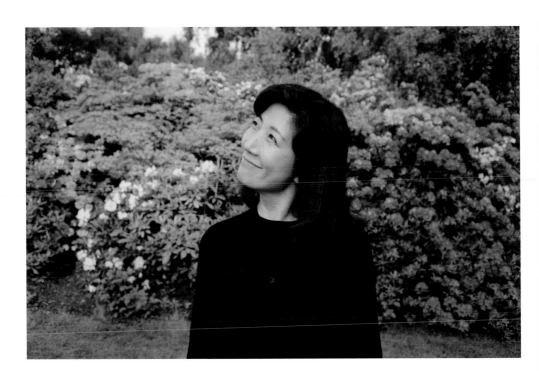

My brother Thein and sister Seyna taking leave of my mother.
She died suddenly from a massive stroke
*Overleaf:* Old gravestone at the church where my mother's ashes were scattered

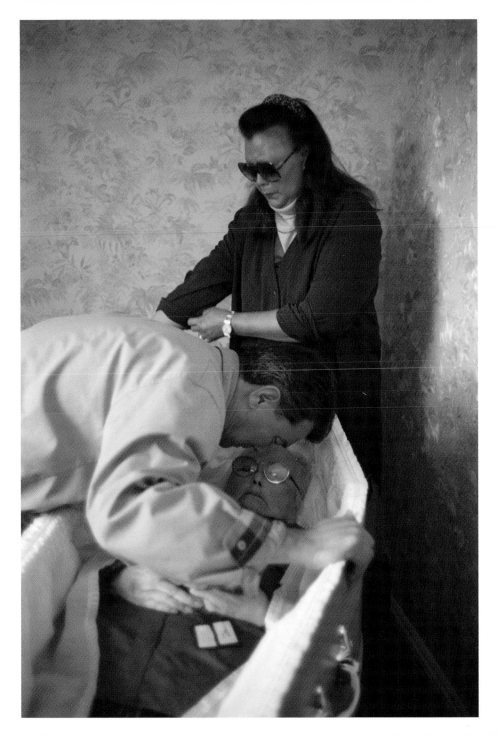

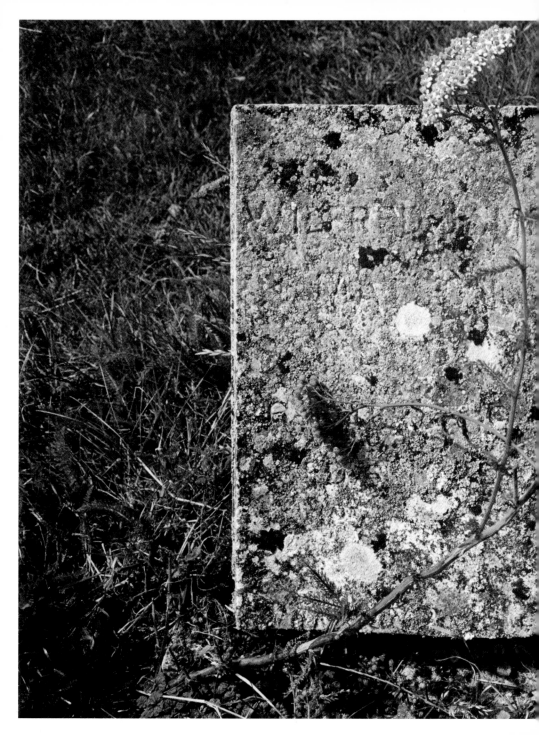

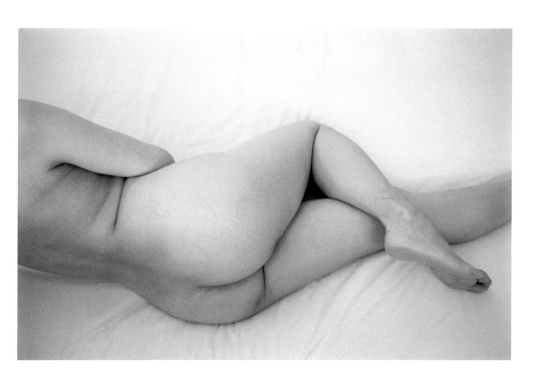

Miyako lying on our bed

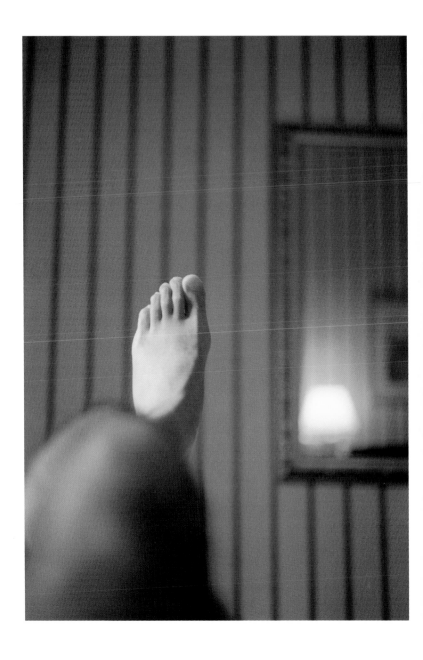

Lying on my bed in a hotel room in New York

Parking lot and Empire States Building in New York
*Overleaf*: Street scene in New York when I was there for a Magnum meeting

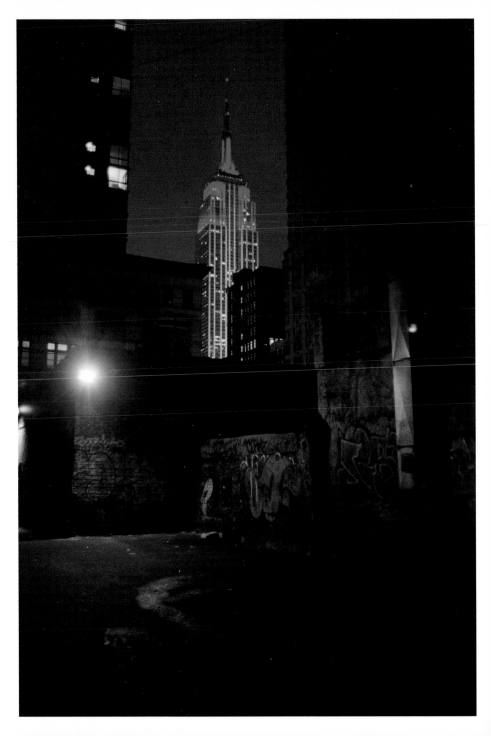

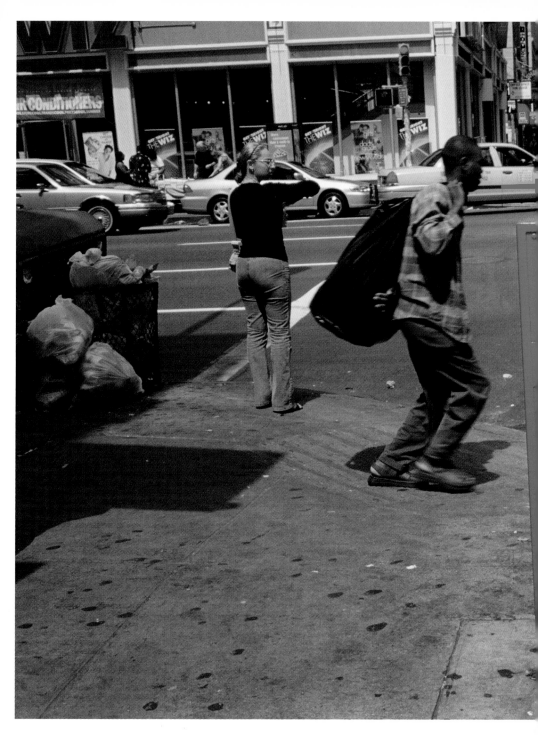

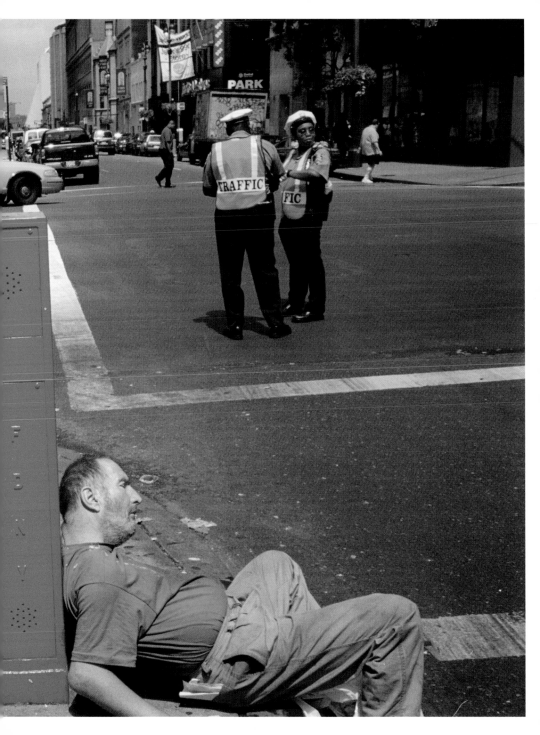

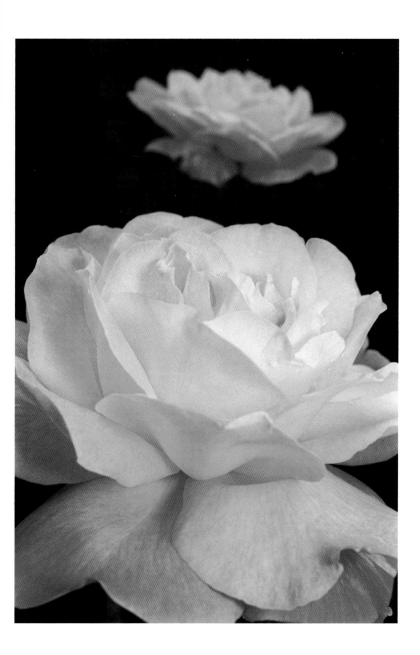

Summer roses in my garden

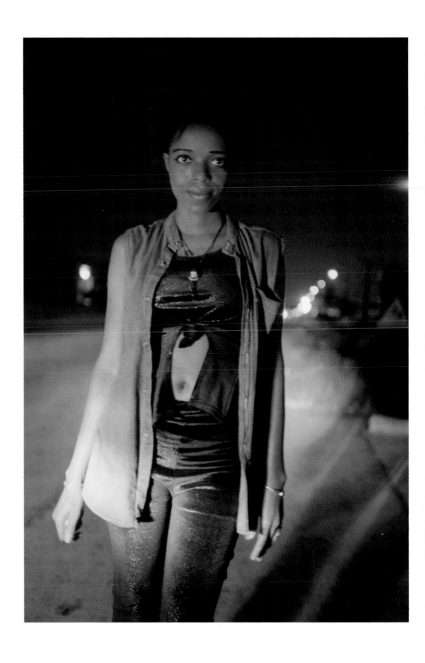

A girl who has been trafficked in Africa working as a prostitute in the Ivory Coast

Slave children waiting to be repatriated by a charity from Gabon back to Togo.
I was working for *Der Speigel*

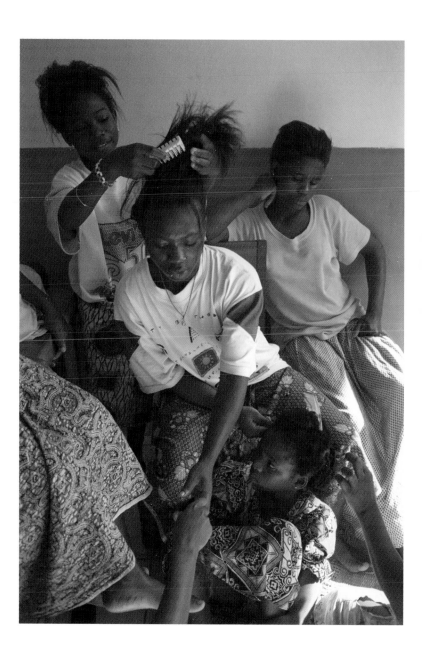

Crescent moon in Kent countryside on the way to a pub meal

Cameron, Cedric and Miyako in the garden at home

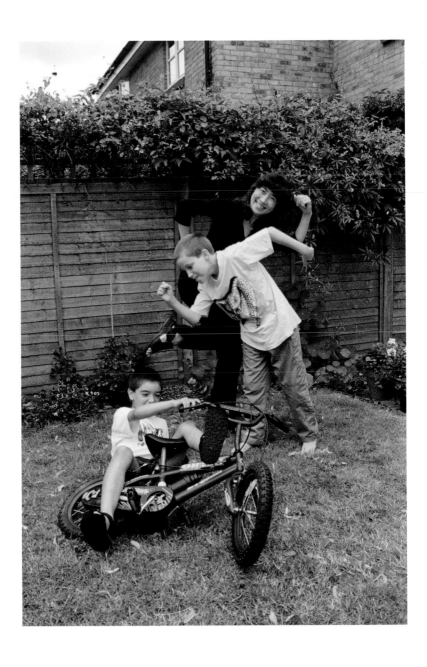

Park in Canterbury where I had taken the family

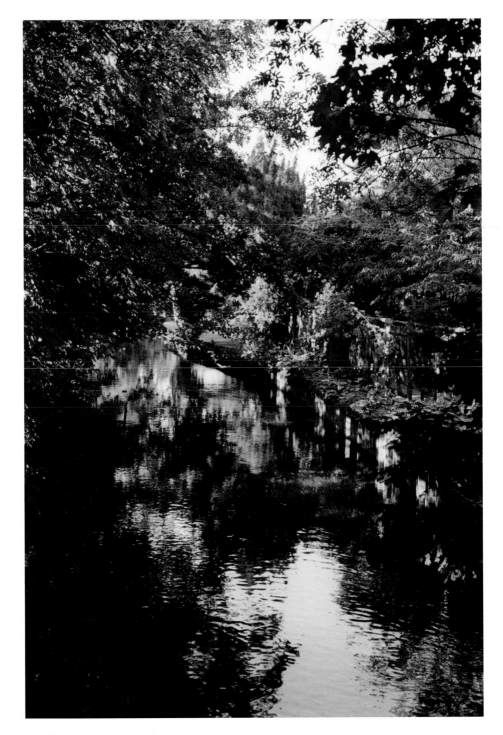

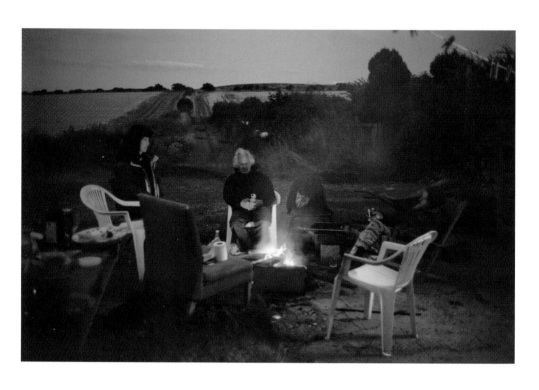

Barbecue at Murray and Ellie's farmhouse in Durham where I was working
on a photographic project on rural life

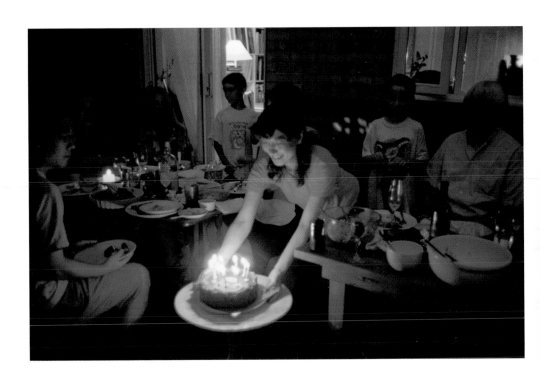

My 54th birthday party. With friends and family in my garden

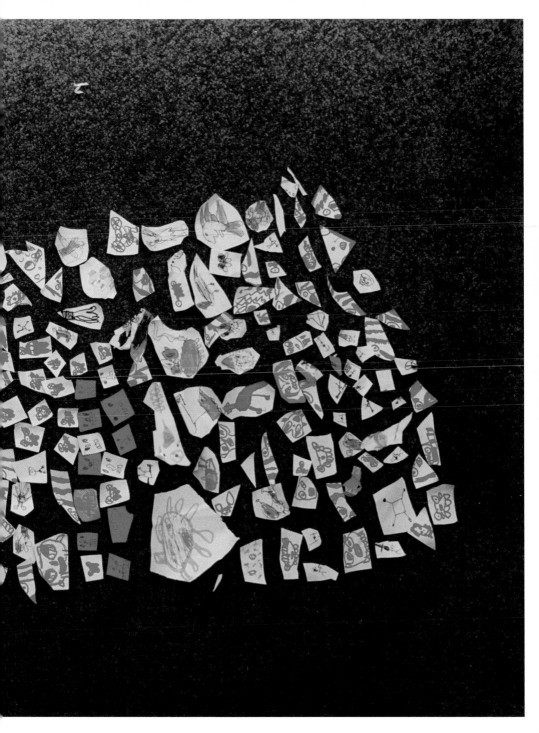

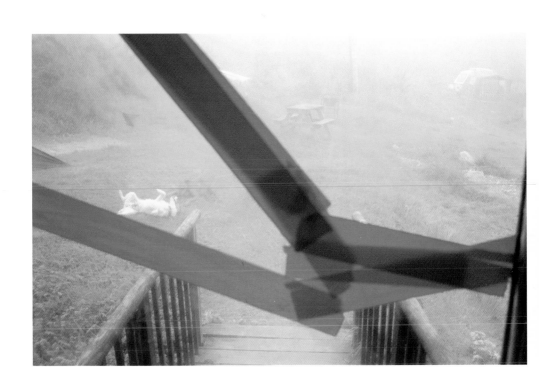

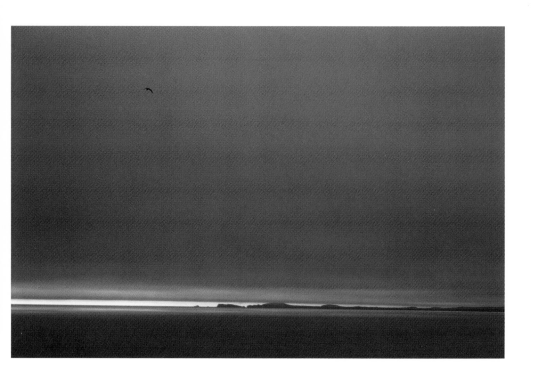

Skyline at dusk off the coast of Wales

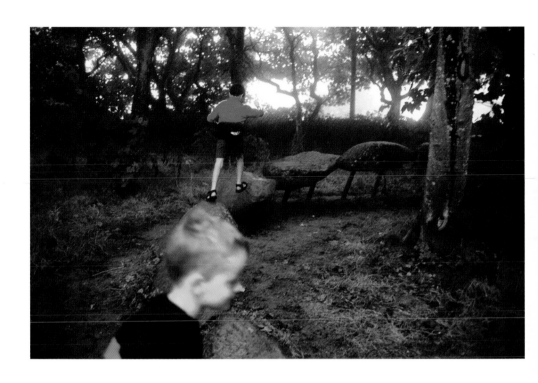

Mackintosh and Cameron with a stone sculpture in Wales

Spider and web in my garden

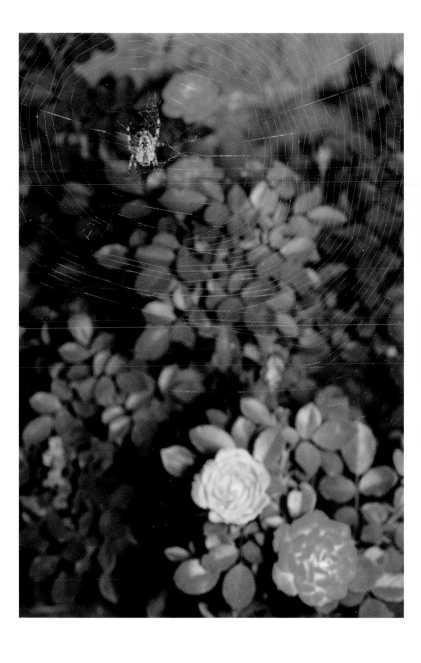

People resting outside Saitama football stadium in Japan
when I was shooting a story on Japanese football

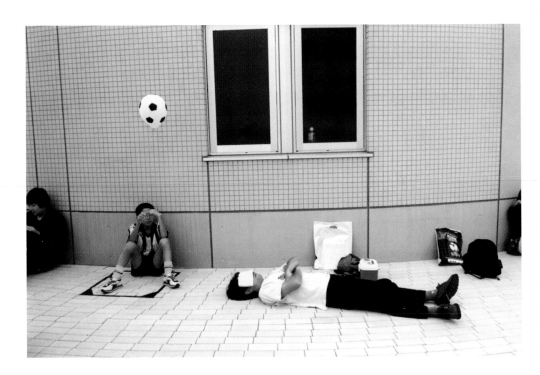

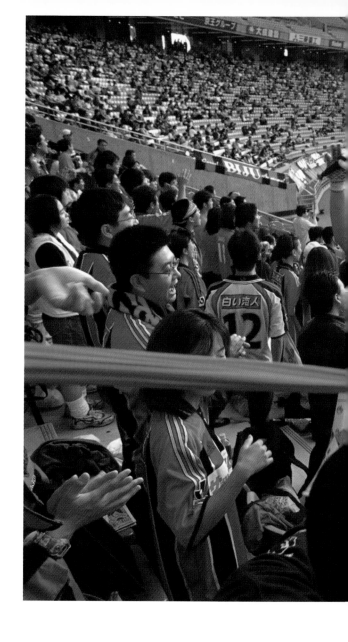

Cheerleaders of Consadole Sapporo
football team at a match
in the National stadium, Tokyo

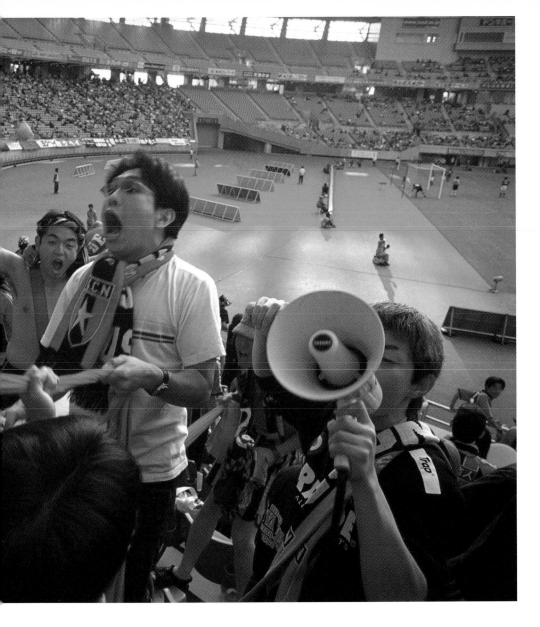

Giant TV screen in the street in Singapore. I was there on a corporate job

Walking in the street in Singapore

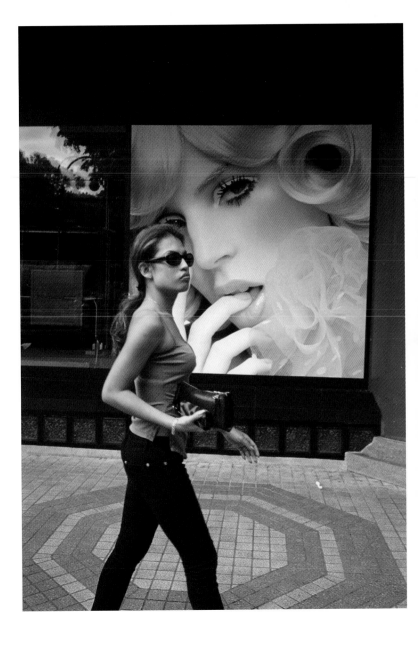

Mt Fuji from a car park on the outskirts of Gotemba

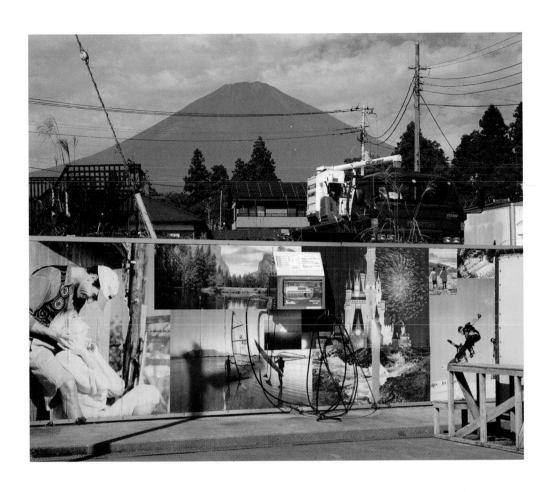

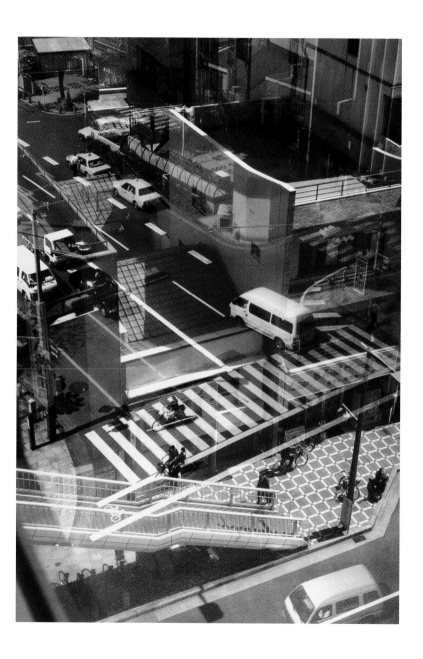

Looking through a hotel window in Tokushima where Miyako was working

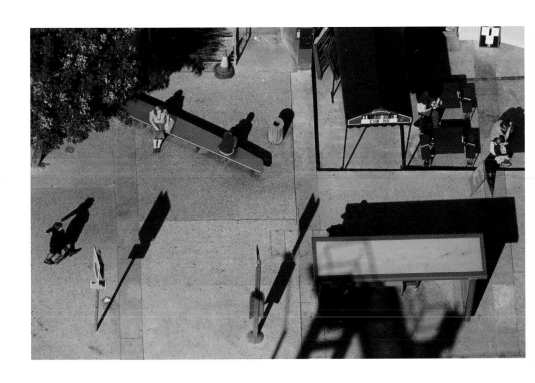

Looking down near London Bridge

A walk in the rain with friends and family

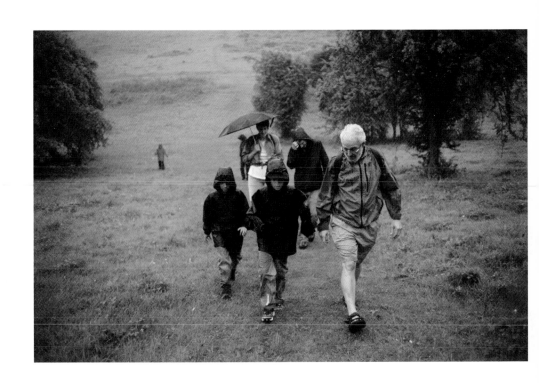

Bicycle in driveway in Castrop-Rauxel, Germany where I was visiting friends

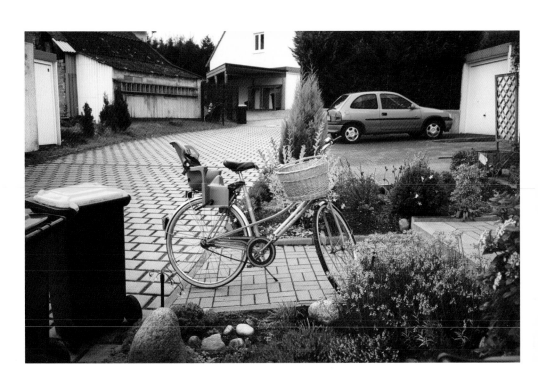

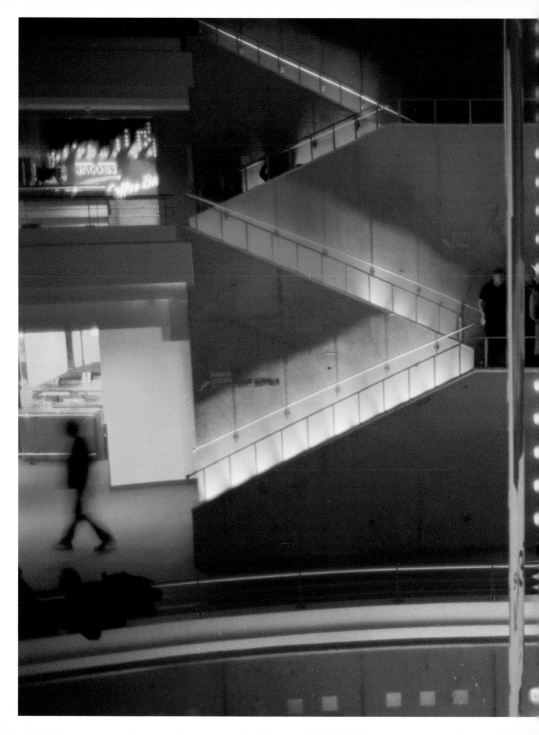

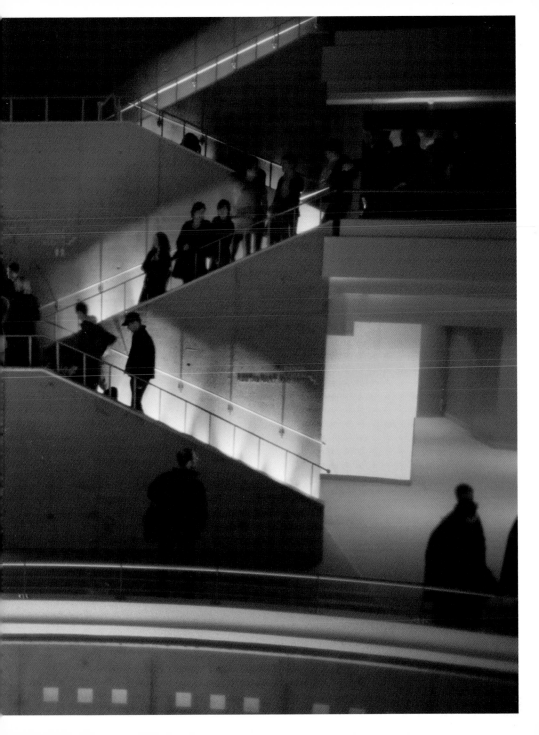

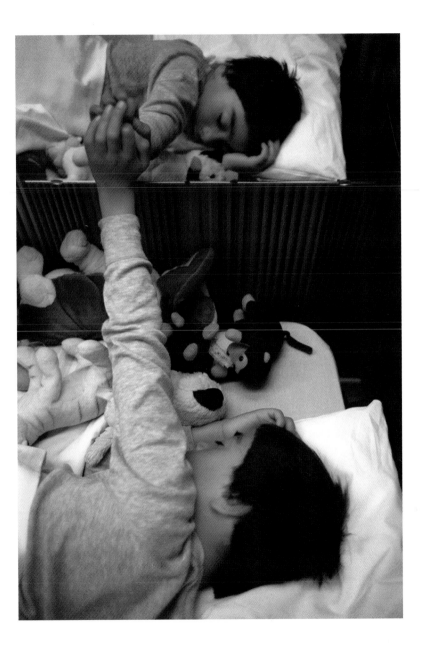

Last of the autumn leaves by Dulwich station

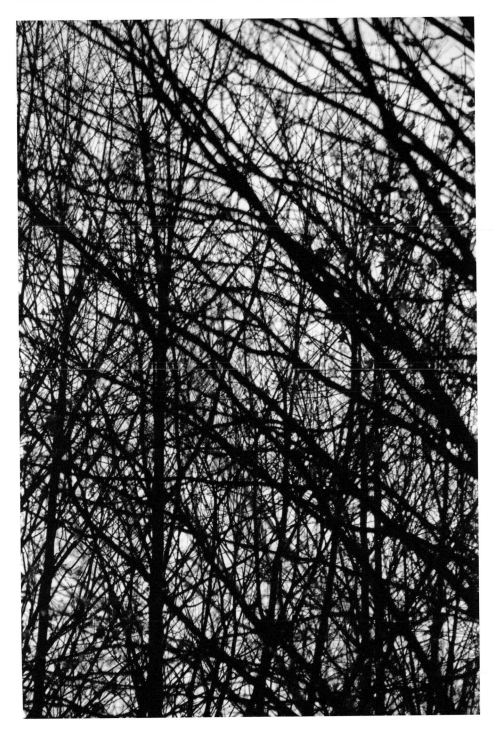

Fireworks on Blackheath Common

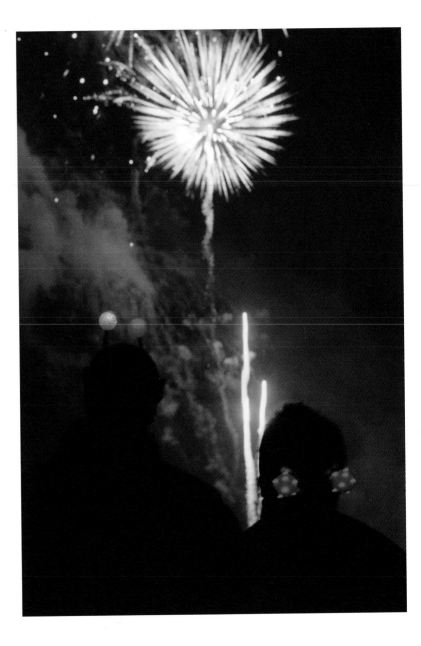

At home on Christmas Day when Mark and Homer came over for lunch

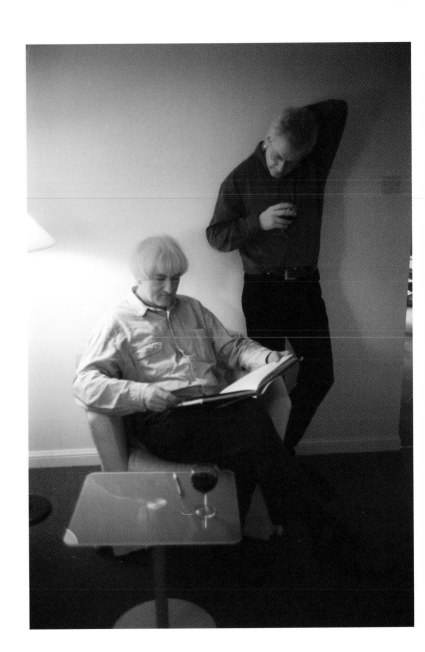

New Year's Eve in the garden with family
*Overleaf*: Waving good-bye to the old, hello to the new, on New Year's Day 2002

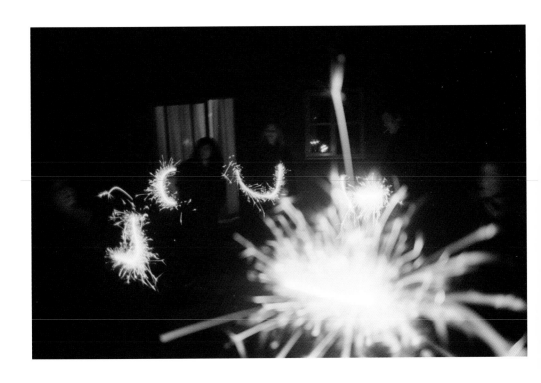

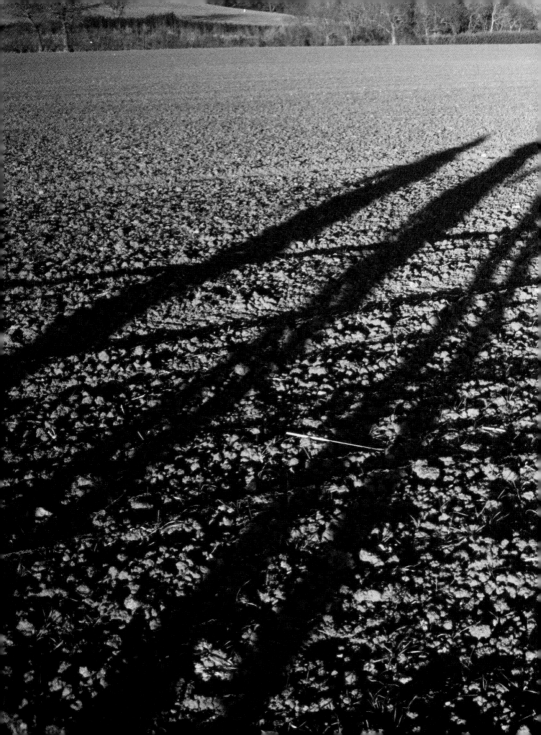

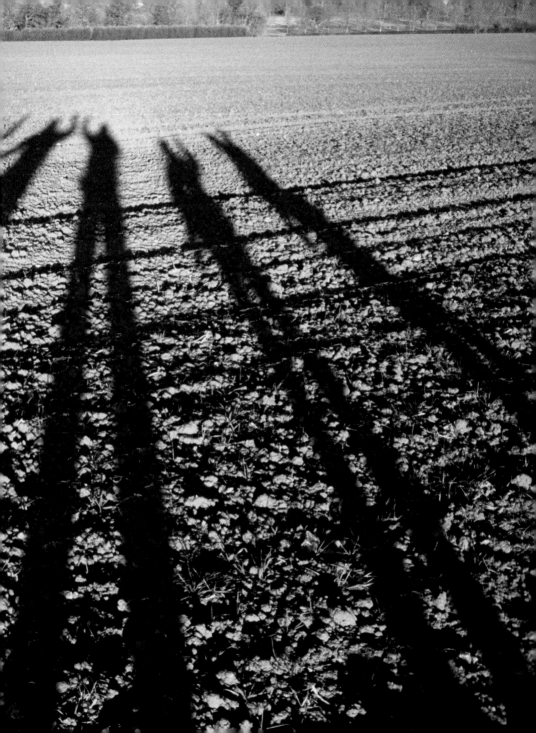

My thanks to my wife Miyako, as well
as to friends and family who appear
in this book.

Some others who have given useful
comments are Nan Richardson,
Zelda Cheatle, Helena Srakocic-Kovak,
Liz Grogan and Diane Auberger.

Various colleagues and staff at Magnum
have also helped in many different ways
and in particular David Axlebank who
made the scans.

Jon Towell took the basic design and ran
with it, and Gigi Giannuzzi took the idea
when it was part formed, kneaded it
and made it happen.

Trolley
Unit 5, Building 13, Long Street
London E2 8HN
www.trolleynet.com

Design Luminous/London

ISBN 1-904-563-11-2

Printed in Italy